Honoring the Ancestors:

The Woodcarvings of Claude Lockhart Clark

June Anderson

A Publication of the California Academy of Sciences • 1997
Distributed by the University of Washington Press, Seattle and London

Cover:
Claude Clark holding the
family memorial stool
"Ralph."
Oakland, 1979.

Photo Credits:
 Caroline Kopp: *1, 5, 27, 36.*
 Claude Clark: *cover, 7, 8, 9, 10, 11, 12, 13, 14, 28, 30a, 38.*
 June Anderson: *6, 16, 24, 25, 26, 30b, 31, 32, 33, 36, 37a-c.*
 African-American Museum and Library: *2, 3, 4.*

All line drawings:
 June Anderson

Book Design by Vivian Young

Printed and Bound in Hong Kong

ISBN 0-940228-42-4

Published in the United States of America
by the California Academy of Sciences
Golden Gate Park
San Francisco, CA 94118
(415) 750-7164

*This book would not be possible without the cooperation of
Claude Lockhart Clark who graciously consented to furnish information on
his family background and his artwork.
Special thanks to Robert L. Haynes and Michael Knight of the
African-American Museum and Library in Oakland for help with
archival and library research.
I am also grateful to Donna Aarons for invaluable suggestions on the manuscript.
The publication of this book was funded by Mrs. Phyllis Wattis, long-time benefactress
and enthusiastic supporter of Anthropology Department programs at
the California Academy of Sciences.*

CONTENTS

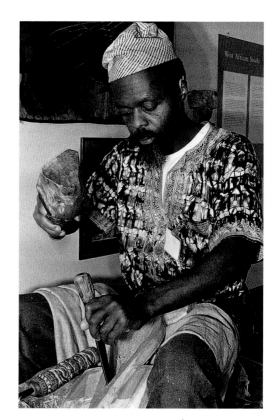

1.
*Claude Clark
demonstrates
woodcarving at the
California Academy
of Sciences, 1991.*

INTRODUCTION

*The San Francisco Bay Area is characterized by its culturally diverse population,
a mix of immigrant and Native American groups who, privately and publicly, celebrate
their ethnic differences through the medium of cultural tradition.*

We find individuals dedicated to conserving their folk art and other creative expressions,
their calendric observances, foodways, folklife customs, and religious ceremonies. The urban
community is home to many talented African-American artists who place great value on their
African aesthetic heritage. This book highlights the work of one of these individuals — Claude
Lockhart Clark, a prominent woodcarver within the East Bay's artistic community. We examine
Claude's work, its relationship to African antecedents, and its close link to his family history.

Claude Clark is one of a long list of craftspeople who have participated in the Traditional
Arts Program at the California Academy of Sciences — San Francisco's natural history museum.
The Academy's Anthropology Department initiated the folk arts program in 1983, ostensibly
as a vehicle for community outreach, inviting local artists to perform their ethnic music, dance,
and storytelling, or demonstrate crafts and culinary traditions, for museum visitors every Saturday
afternoon. The program also functions as a means of cross-cultural communication; artists
welcome the opportunity to interpret their own culture and educate members of the audience on
the beliefs and values of their ethnic group during their presentations. This type of intercultural
exchange is vital in a pluralistic society where misconceptions and ethnic stereotypes exist mainly
from lack of understanding.

In conjunction with the ongoing folk art series, Academy staff conduct fieldwork in city
neighborhoods to identify artists for the program, document their artwork in its cultural context,
and augment the data with library research on folk art genres. Over the years the museum has
amassed an extensive archive of local folklife material, including a significant photographic
collection, as a valuable resource for other researchers in urban ethnography.

This publication draws on the Academy's archival material as well as interviews with Claude
Clark in his home where he agreed to share personal information and aspects of his cultural
heritage with us. Claude has participated in many programs at the museum, ranging from one-
hour wood-carving demonstrations to month-long residences. His presentations have provided
a further opportunity for documentation, particularly the audience response to his work.

Although this book honors the contributions of a single artist, within the Bay Area thousands
of individuals from diverse backgrounds continue, without public fanfare, to perpetuate their
folk art traditions as part of the daily fabric of life within their social groups. Thus Claude's work
represents both the local African-American community and that special group of artists who look
to their cultural heritage for creative inspiration, who seek to maintain a sense of ethnic identity
through their traditional art, and who strive to pass on their knowledge and skills to the next
generation.

COMMUNITY

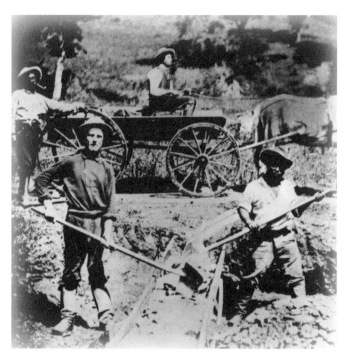

*2.
African-Americans worked alongside European-Americans mining for gold. Spanish Flat, 1852.*

African-Americans have played an active part in California's history from its early beginnings. At the peak of the Gold Rush in 1849, freed slaves joined other gold-seekers going west.

However it was more than the lure of gold that attracted black pioneers to California; it was the dream of open land and a new society more accepting of racial differences than the eastern and southern states. California, an abolitionist state, offered the promise of greater freedom from discrimination and segregation. On arrival, African-Americans found other blacks already on the scene, mining for gold — Afro-Hispanics among the Mexican colonists and Africans from the Caribbean and South America (Crouchett *et al.*, 1989).

After the Gold Rush frenzy, blacks faced the challenge of the western frontier and, in the San Francisco Bay Area, created an African-American community where none had existed. Settlers soon established a support system of social institutions — churches, schools, and small businesses, predominantly in the East Bay where land was affordable. In 1857 Oakland boasted its first private school for black children. (The Oakland Board of Education did not integrate public schools until May 1872.) In 1858, the first all-black church was established in Oakland, an African Methodist Episcopal mission. In 1863 it formally acquired a building and a minister, becoming the Shiloh African Methodist Episcopal Church.

Finding work was not easy for members of the fledgling community in the post-Gold Rush period, as men competed with immigrant Chinese laborers for jobs. Yet, despite the racial prejudice that existed in California as elsewhere, many blacks prospered during the 1850s and realized their dream of owning property and their own businesses. Families purchased choice city lots in Oakland and, by the end of 1860s, the small black community in the East Bay had developed unity and identity.

In 1869 the Central Pacific Railroad (later to become the Southern Pacific) chose Oakland as the western terminus for its transcontinental route. The coming of the

railroad created a labor market and sparked economic expansion in the East Bay. Black migration to the area increased when the Pullman Company established a policy of hiring blacks as porters on their sleeping cars. A growing number of Pullman porters and their families made Oakland their home base. Other companies hired blacks to work as cooks, dining car waiters, baggage handlers, and in the railyards. As employees were required to be on call, black families moved to West Oakland to be near the railyards. Some lived in company-owned rooming houses, others bought homes. With the influx of new-comers, the black population in Oakland numbered 593 by 1880.

With the East Bay African-American community growing in size, blacks sought professional careers to meet the needs of local people. Oakland's first black physician set up practice in 1894. In 1896 the first black man passed the State Bar examinations, but the California Supreme Court refused to admit him; regardless, he opened an office and practiced law, and the Court later reversed its decision. (The first black woman to be admitted to the California Bar was Virginia Stephens in 1936.) The first black-owned newspaper in Oakland, the Illustrated Guide, was founded in 1892. At the turn of the century over one thousand African-Americans lived in Oakland, with a nascent community numbering 66 forming in Berkeley.

Between 1900 and 1910 the East Bay black population tripled, to over 3000. Many refugees from the 1906 Earthquake and Fire in San Francisco who escaped to the East Bay decided to stay. Blacks found certain advantages over San Francisco; housing was cheaper and employment opportunities more plentiful (Crouchett *et al.*, 1989).

Earthquake refugees merely added to the rapid growth process brought on by an industrial boom in the region which triggered a shift in demographics. Competing with San Francisco as a major West Coast port,

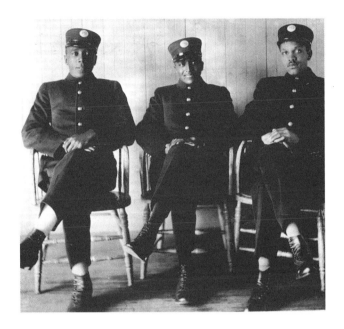

Oakland secured a large federal shipbuilding contract in 1910. The Santa Fe railroad built a local transit system extending to Richmond where cheap land and easy access to the city made it a prime target for industrial and residential development. Standard Oil soon established facilities there, creating job opportunities and the prospect of affordable housing in new rural tracts. This was a major attraction, since the Oakland City Council still prohibited blacks from buying property in some of the new tract communities.

At the onset of World War I, the federal government awarded contracts to local ship-building firms, iron works, and vehicle manufacturers, and production soared. The dwindling labor force due to the war effort forced companies to hire blacks for positions usually assigned to whites. After the war, civil service jobs began to open up, partly because voters from the rising black middle classes were now in significant numbers to wield leverage in discrimination cases. In 1918 Oakland started to hire black police officers, post office workers, and firefighters, although the latter were segregated in a separate fire-house. The 1920 US Census gave the Oakland population at 216,261, of which 5489 were of African ancestry.

3.
Oakland fire-fighters at the segregated firehouse at Eighth and Alice Streets, c. 1920. From left to right, Price N. Crawford, Clarence Rhodes, and Roy Treece.

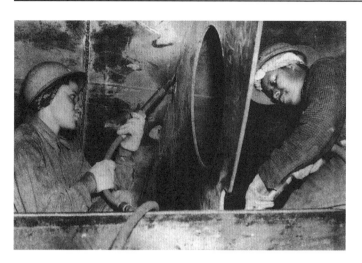

4.
Wearing hardhats, women "chippers" work on a metal section of a ship's hull in the Kaiser Shipyards. Richmond, 1943.

The Great Depression brought an abrupt end to economic growth in the Bay Area. Layoffs in Richmond were particularly high, and many blacks were forced to seek public assistance or federally-funded jobs through the Works Progress Administration. However, a second industrial boom was on the horizon. The advent of World War II created a labor demand in local factories, but the enormous mobilization of men into the armed services left a gap in the workforce. Labor recruiters travelled to the poverty-stricken Dustbowl states in the South to enlist workers for the shipyards.

The Golden State beckoned — the Promised Land, free of Jim Crow laws, though in reality still a place where civil rights were often disregarded. Black men who weren't soldiers migrated first, later sending for their families from their earnings. But a fair proportion of blacks who boarded segregated trains for the westward journey were southern black women whose husbands had gone to battle. They also joined the war campaign, donning welders' helmets and steel-toed shoes to do "men's work" at Oakland's Bethlehem Steel shipyards and Richmond's Kaiser shipyards (Lemke-Santangelo 1996).

Between 1942 and 1945 the East Bay black population swelled by a staggering amount, with recent arrivals outnumbering the established citizenry. Over 50,000 African-Americans moved to the area, and the black community in Oakland alone went from 8,462 in 1940, to 47,562 in 1945, double that of San Francisco; Richmond's black population increased from 270 to 10,000. Now a dynamic presence, the sheer volume of black newcomers transformed Bay Area society in the 1940s and, for the first time, racial tensions became visible and overt public discrimination increased.

When the war boom ended in 1944, shipyards inevitably began to lay off workers. Although many lost their jobs, there was no mass reverse migration. Families and war-widows stayed in the cities rather than return to the rural South, though most of the housing for black shipworkers was quickly demolished in an effort to push migrants out of town.

The focal point of African-American life in San Francisco during the 40s and 50s was the Western Addition, and the Fillmore District in particular — a lively jazz club district with the vibrancy and character of 1920s Harlem. As the city expanded, the area became prime real estate, and the neighborhood succumbed to the developer's bulldozer and gentrification. San Francisco's African-American community, with deeply-embedded roots, became fragmented; many families moved further out to other enclaves of the city, settling in Hunters Point, Bayview, Ingleside, and Visitacion Valley — areas that remain predominantly African-American today.

In the postwar era, African-Americans gained a foothold in local politics. The first black elected official in northern California was appointed to the State Assembly in 1948, and Alameda County's first black judge, Lionel Wilson, took office in 1960, later becoming Oakland's first black mayor in 1977. At that time Oakland's African-American populace numbered 124,710.

Black jounalist Robert Maynard became editor of the Oakland Tribune in 1979, its publisher in 1981, and owner in 1983. In San Francisco, Willie Brown became the city's first African-American mayor in 1995.

According to the 1990 US Population Census, 7.4% of Californians are of African ancestry. Within the nine Bay Area counties, the distribution is as follows:

San Francisco	10.9%
Alameda	17.9%
Contra Costa	9.3%
Santa Clara	3.7%
San Mateo	5.2%
Marin	3.5%
Napa	1%
Solano	13%
Sonoma	1%

The Bay Area's African-American population continues to grow with influxes of new immigrants from Africa, Brazil, and the Caribbean. When a military coup dethroned Ethiopian Emperor Haile Selassie in 1974, many fled the Marxist regime and came to the United States as political refugees. There are now around 5000 Ethiopians in the Bay Area. In the 1980s, Eritreans began arriving in significant numbers due to the war over secession from Ethiopia and their struggle for self-determination as an independent Eritrean nation. Moreover, a sizeable Nigerian community has taken root in the Bay Area.

Over the past century, African-American expressive culture has thrived in the Bay Area, which developed into a vital center for gospel music, blues, and jazz, and for recording companies, night clubs, and other outlets for the music (Collins 1992). Art flourished, and today we find the region rich in all forms of African-American music, dance, storytelling, and crafts, as well as social clubs, churches, restaurants, art galleries, museums, and cultural organizations such as the African-American Historical Society, Wajumbe Cultural Center, the Black Cowboy's Association, the Black Filmmakers Hall of Fame, the Black Writers Guild, the Bay Area Blues Society, and the Friends of Brazil Club. The Caribbean is well-represented with Jamaican storytellers, Haitian dance groups such as Group Petit La Croix, and Cuban music and dance ensembles, notably Raices Afrocubanas and Conjunto Cespedes.

African-American cultural events take place throughout the year. The last weekend in May showcases Carnival, modelled after pre-Lenten Mardi Gras festivities. The street parade brings together a variety of groups — Brazilian samba schools, Trinidad steel bands, *capoiera* performers, Louisiana Cajun and Zydeco orchestras, and the sounds of Jamaican reggae. Local Carnival balls rival those of New Orleans, Rio de Janeiro, and Port of Spain. June is the month for the Juneteenth celebrations, commemorating the official end of slavery in Texas on June 19th, 1865, when the state finally ratified the Emancipation Proclamation two months after the end of the Civil War. Over the past twenty years, Juneteenth has spread beyond Texas and is now a popular calendric observance throughout the United States.

Local African-Americans embrace the comparatively recent custom of Kwanzaa, a seven-day nonreligious holiday created by Dr. Maulana Karenga in 1966 at the height of the black civil rights movement. The word *kwanzaa* derives from *matunda ya kwanza* meaning "the first fruits of the harvest" in Swahili. In continental Africa there is no equivalent holiday to Kwanzaa; Dr. Karenga synthesized elements from many different African practices associated with first fruits celebrations to invent this uniquely African-American occasion.

Kwanzaa is a time to reflect on African heritage and reinforce basic communal values. Beginning the day after Christmas and ending on January 1st, each day a family member ceremonially lights one of seven red, green, or black candles *(mishumaa saba)* in the seven-branched candle-holder *(kinara)*, and discusses one of the seven guiding principles *(nguzo saba)* on which Karenga based his philosophy of daily life: unity *(umoja)*, self-determination *(kujichagulia)*, collective work and responsibility *(ujima)*, cooperative economics *(ujamaa)*, purpose *(nia)*, creativity *(kuumba)*, and faith *(imani)* (Karenga 1988).

African-derived religions and belief systems have a strong following in urban neighborhoods. Practitioners of Yoruba Lucumi uphold Old World spirituality and tenets, performing ceremonies and intiation rites associated with the worship of African gods or *orishas*. Sacred songs, drumming, and dance are essential ingredients in the rituals. Afro-Cuban Santeria and Haitian Vodun manifest the same ideology stemming from West African roots (Osumare 1992).

The array of talented artisans of African heritage in the community include quilter Arbie Williams, the recipient of a National Heritage Fellowship in 1991, woodcarver John Abduljaami, drum-carver Moshe Milon, shekere-maker Avotcja Jiltonilro, steel pan fabricator Ansel Joseph, doll-maker Jeanetta Ife Sanders, hairbraider Cheri Anderson, Senegal slit-drum carver Blaise Guillen, textile artist April Watkins, Eritrean basket-weaver Brekti Bahta, Virgin Islands chip carver Doris Shirault, and herbalist Tureeda Mikell, to name but a few.

From this pool of traditional artists, we focus on the work of Claude Lockhart Clark. Claude carries on a living tradition of wood-carving that affirms his African-American identity. Through his frequent visits to schools, museums, and other public venues to demonstrate his skills, Claude acts as a role model to the younger generation. The message is clear; in promoting his culture in community programs, with commitment and respect, he encourages others to follow his example and conserve their African heritage. Concerning the importance of cultural trans-mission, Karenga writes: "To be a custodian of a great legacy is to guard, preserve, expand, and promote it. It is to honor it by building on and expanding it and, in turn, leaving it as an enriched legacy for future generations" (1988:65).

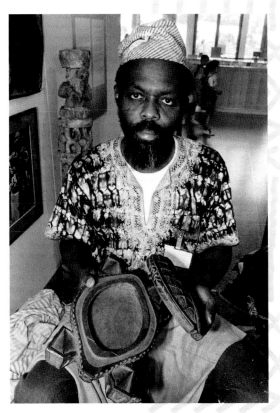

5.
Claude Clark with one of his turtle-shaped boxes. California Academy of Sciences, 1991.

THE ARTIST

6.
Claude outside his home, 1996.

Enter Claude Clark's home and wood welcomes you — furniture and floors, beams and boards, painted oak panelling, carved African masks, etched calabash bowls, stately sculptures, and small figurines.

Each room houses a treasury of wood art fashioned by Claude's hand as well as those of others. Blocks of lumber hide in corners, awaiting transformation by a master craftsman into intricately-detailed ancestor stools or totemic animal-shaped boxes. The occupant of this small, timber-framed house, situated on a quiet tree-lined Oakland street, is a man who loves wood, an artist who has chosen wood as the medium for his creative energies, or maybe the wood chose him. Trees, timber, lumber, logs, carvings—Claude lives in a world of wood that envelops his daily life.

Wood was not the first love of his artistic life. At age fourteen, he began making ceramic figures of hollow clay construction, under the guidance of his grandmother, Alice Buchanan. As a high school student in the 1960s he experimented with bronze casting. By the time he was eighteen Claude had completed over 110 ceramic and metal pieces.

As a student in the Oakland Public School District, Claude remembers learning about art "through the distorted filters and limitations of the European American environment. I was taught European art in secondary school and in art college because that was the only art the teachers that taught

me knew. African-American studies hadn't started yet."

Born in 1945 in Philadelphia, Claude strongly identifies with his father, Claude Clark Sr., a painter and printmaker who has exhibited his work throughout the United States and abroad. Until his retirement ten years ago, Claude's father taught African and African-American art history at Merritt College in Oakland. Father and son have shown their work together in many exhibits and, in 1970, co-authored "A Black Art Perspective," a teachers' resource manual and curriculum guide on African-American art and its aesthetic roots.

Claude grew up in a household surrounded by art books. In the 1950s Claude's father was teaching art at Talladega College in Alabama. By the age of seven years, Claude was familiar with the books on African art in his father's book collection as well as the plaster copies of African sculpture that his father bought at the University Museum. Claude now has his own book collection of over 200 books on African art.

In Philadelphia during the summer of 1972, Claude met Lamidi Olanada Fakeye, a Nigerian artist descended from many generations of Yoruba woodcarvers. Fakeye studied art in Paris and is a recognized contemporary artist in Nigeria as well as in the West (Wahlman 1974). Claude spent several weeks watching him work; this triggered his exploration into a new medium — wood. He became interested in West African art forms and began to draw on his African heritage to develop themes that blended traditional elements with personal statement. Since then he has visited Africa many times in search of information about his cultural heritage.

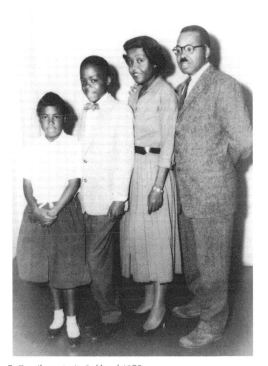

7. Family portrait, Oakland 1975.
Daima Clark and Claude Clark Sr. with their children,
Alice Shasta and Claude.

In 1972 Claude received an MA in sculpture from the University of California at Berkeley. Today he is a well-known artist in the Bay Area, experimenting with printing, water colors, and pen and ink drawings as well as wood, and has received many merit awards for his pieces. Academic positions include lecturing in the African-American Studies Department at San Jose State University and, following in his father's footsteps, teaching African and African-American art history, at the California College of Arts and Crafts in Oakland. As a sideline, Claude augments his income as a dealer in African art.

Claude calls himself "a maker of art and images" and comments: "I don't do sculpture to beautify, or do it for its own sake. When it is finished, the work must then do something for me." He believes strongly in following a pursuit "because you like doing it, not for the money" and that formal education is vital. When giving encouragement to his cousin, Christine Vann, he advised: "If you don't have a productive skill, by all means go to a trade

school or college and get one. Be sure that whatever you take, you don't take it for the money but because it's something you seriously want to do. You will work at it harder and longer than you would if it were something you didn't like. Find something you like to do, go for it, then figure out how you can become employable or self-reliant."

Claude practices what he preaches and adds the following example from his own experience: "I took private lessons in computers at night, because it was something I wanted to learn. I didn't have any use for a computer at the time, I only wanted to be better informed. I plan to get a laptop computer so that I can improve my skills. I am not interested in making a career of it. I just want to make my work load easier, and punching a keyboard is something I like to do."

In addition to his artistic pursuits, Claude is the self-appointed family archivist and genealogical researcher. His is a close-knit family that places great value on kinship and documenting family history. It's a family that kept detailed records, that wrote things down, maintained diaries and family Bibles, saved birth, marriage and death certificates — a wealth of information and reminiscences handed down matrilineally through six generations from the 1820s. Few families today can boast such a compendium of historical knowledge. Claude traced his mother's lineage as far back as his great-great-grandparents Ralph and Emily Booker. Claude remarks, lightheartedly: "Perhaps the name Booker may suggest the reason I record the family history in all of those volumes and books; it is possible that a person keeping such records is called a *booker*."

8. Emily Booth,
late 19th century.

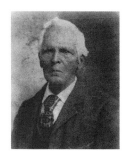

9. Ralph Booker, 1890s.

Claude recollects: "My mother's side of the family has extensive records. It was the women rather than the men who kept memories alive, who recorded events, passed on personal anecdotes, and documented their lives." Family members were, and still are, scattered throughout the country, so it was usually get-togethers such as wakes and funerals that provided an opportunity to pass on information and swap family knowledge. "By the fifth generation I became guardian of our oldest original documents, such as private letters, property deeds from the last century, photographs, and other vital records. At times it is confusing to piece it all together. I was faced with too many Ralphs! That name has been repeated more times than any other in our family's history — nine times over six generations—and one branch of the family is still using the name today."

"Accurate record-keeping is a characteristic in this family, particularly among the school teachers. We've had a lot of them in the family, since the first school teacher in 1880. Also, the people on my mother's side are known for owning property since 1867. My grandmother once described her people as 'school teachers and property owners'."

Claude feels a responsibility to inform the living, as well as compile information concerning the dead. "I dispense information about the past, depicting family traditions to living relatives throughout the land. For me, it is a very time-consuming, expensive job, but I do it." For example, in 1992 Claude received a letter from his cousin, Christine Vann, asking about her ancestors: "My mother said you get really deep into the family tree and you know everything." This marked the beginning of a correspondence with his cousin, a regular exchange of letters explaining the family tree. For Christine, Claude was able to reconstruct her past, introduce her to long-dead progenitors, and give her a sense of place and identity.

Both sides of Claude's family came from the southeastern states—North Carolina, Georgia, and Alabama. On his father's side, the first ancestor arrived from Africa six generations ago. Claude comments: "We don't know his name. One of his sons, born in this country, was given a European name —George Clark. He is my great-great-grandfather. In 1981 I found his name in the 1880 census for Terrell County in Georgia, while searching through the national archives in San Bruno, California. He is listed as head of the family, and his birthplace as Alabama, but his father's birthplace is listed as Africa. One of George's sons, age six years, is listed as William Clark, my great-grandfather."

On his mother's side, Claude's family history starts with Ralph Booker, born in 1820 in Georgia, and his wife Emily Booth, born in 1824 in North Carolina. Although slavery still existed at this time, Ralph and Emily were both born free. The couple had fourteen children, of which only twelve (seven boys and five girls) have been identified through family documents. Their daughter, Sophie, born in 1854 in Kansas Territory, is Claude's great-grandmother. Sophie married William Buchanan and had seven children, three boys and four girls. One of the sons, John Ellis Buchanan, born in 1879, was the first minister in the family; there have been three since then. One of the daughters, Alice Buchanan, is Claude's maternal grandmother. Alice was born in 1882 and grew up on a homestead outside Alvin, Texas. Many of the Bookers/ Buchanans worked as farmers and domestics.

Alice Buchanan visited New England, California, and even England before she married Clark Jackson Lockhart on November 18, 1914, when Alice was 32 and Clark was 49. Concerning his grandfather, Claude reveals: "For me the word slavery is not an academic term connected with ancient history. For me, just a mere mention of the word slavery brings to mind my grandfather. When the Civil War ended, the state of Georgia ratified the proclamation which

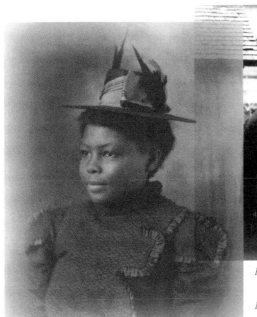

10. Claude's grandmother, Alice Buchanan, as a young girl; Alvin, Texas, 1894.

11. Alice Buchanan on the homestead in Alvin, Texas, 1911.

12.
Claude's grand-father,
Clark Jackson Lockhart;
Thomaston, Georgia, 1890s.

13.
Claude's great-grand-
mother, Patsy Jordan;
Georgia, c. 1900.

abolished institutional slavery on May 29, 1865, and my grandfather Clark Jackson Lockhart was born in Georgia on March 17, 1865. When Clark was of work age he never worked as a slave. He did work as a sharecropper, and for the first few years of his life, his family worked on the same plantation they were enslaved on. He heard all the horror stories of what happened to his ancestors."

From the many family documents in Claude's possession, we learn that the father of Clark Jackson Lockhart, Louis Lockhart, was born into slavery in Georgia in 1840. Lockhart was the name of the plantation owner. Louis was one of 23 children, though there are no records of his parents. The plantation was "six to eight miles long, and about two miles wide."

In 1865 Louis married Patsy Jordan according to slave custom by "jumping over a broomstick"— the only ceremony permitted for slaves. Not satisfied with this non-legal marriage, the couple procured a license in 1867, after slavery ended in Georgia, and had the nuptials officially recorded.

Claude's family letters reveal that his great-grandmother, Patsy Jordan, "had a great deal of Indian blood in her. She was inclined toward being independent and wasn't inclined toward accepting impositions from the overseers. She was a very good-looking woman and therefore physically attractive to the overseers. She resisted their advances. In several

instances she did bodily harm to overseers who were persistent in their advances. In this she was upheld by her mistress."

After the abolition of slavery, Louis and Patsy Lockhart remained on the plantation as sharecroppers. In 1874 they moved to another plantation five miles away. Their son, Clark Jackson, now attended school, but for only three months a year, and his first teacher was white. Around 1880 nine-month schooling was instigated, when Clark was fifteen.

Louis now rented a half-mile square of land for which he paid two bales of cotton annually from the eight to ten bales he produced a year. As well as cotton, he grew corn, watermelons, pumpkins, and turnips. He and his wife owned cows, for milk and butter, and they lived in a four-roomed house. Patsy was a midwife and charged two dollars per delivery.

Their son, Clark, left Georgia in 1903 for Birmingham, Alabama, to dig ore in the mines. After eleven months he moved on to New Orleans — in a hurry. "White man cussed him out by calling him a son of a bitch. Clark went after him with a pocket knife and injured him seriously." In New Orleans he bought a piece of property and opened a laundry and, in 1906, became a Methodist minister at the Church of St. Paul.

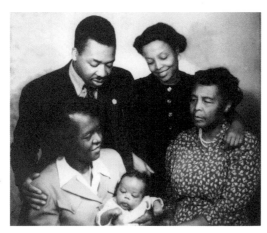

14.
Three generations of the family, Philadelphia 1945. Baby Claude with his parents, Aunt Abilene, and Grandmother Alice.

In 1911 Clark left for San Francisco. He became the owner of a furniture store at 591 Seventh Street in Oakland. Clark met his future wife, Alice Buchanan, in 1913 while she was visiting California from her home in Texas. Their's was a brief courtship, conducted mainly through correspondence. Claude's family archives contain all the love letters that passed between Alice and Clark during their one-year long-distance romance.

Alice and Clark Lockhart had six children. Claude's mother was born by the name of Effie Mary Lockhart on October 3, 1915, when her father was 50 years old. (As an adult, she changed her name from Effie to Daima for personal reasons.) Claude recollects: "Grandmother Alice and Grandfather Clark raised their children in the small town of Riverside, California. In those days, Riverside became the family Mecca, or family stomping ground, for all the Bookers and Buchanans living in southern California. Family members kept in touch and we developed strong ties with cousins."

Claude remembers one first cousin in particular, Dr. Arthur Booker, "who used to come from Los Angeles to visit occasionally. Dr. Arthur Booker was the most widely-known member of our family. To us he was a guiding light, a sign of hope. Our grandmother use to pump us with stories about family achievers as though she was pumping our

veins with blood plasma. Since most of grandmother's own children didn't achieve as much as she would have liked, she pushed us so that we would work harder in school."

"Grandmother Alice placed great value on education. She only went as far as the third grade in school. She educated herself by reading the Bible and grade school materials that her children brought home from school. In later years, whenever she visited the homes of her grandchildren, she read our college materials."

"At Christmas and birthday time each of us would receive a handwritten note and a dollar bill. The note written in very poor broken English always ended with "here a dolla' bill for you to buy pencil, paper and book." The effect was absolutely devastating; sometimes you nearly cried. It wasn't that you didn't feel you deserved a gift. It was the psychology she used behind the gift in her letter. She always kept you focused. My parents could offer me so much more, yet I can't remember most of what they ever gave me, except the love and attention, which was consistent. Those notes and dollars Grandmother Alice gave me piled up in my drawers, and when I needed one they were always there. I got used to the dollar and notes after a while. As the years passed she didn't send them as often. Some years one would come at Christmas, or your birthday, and some years you didn't receive anything. Occasionally she would catch you off guard by sending you a note with a dollar bill when you least expected it."

"I had used up all of my dollars by the time I entered graduate school in 1968. In 1991 I happened to be going through a box of family papers when I found this envelope from Grandmother Alice. Inside was her letter and a "lucky" dollar bill. I was running late for a job interview, so I didn't have time to go to the bank. I used the dollar for bridge toll. Thank you, Grandmother."

Alice Buchanan's emphasis on education bore fruit; her influence on the family is apparent in the accomplishments of her grandchildren. As Claude observes: "We produced a few professionals. This branch of the family has several people with double and triple professions — trained in more than one skill. That trait seems to run in the family. One first cousin, Calvin Jessel Strong, holds a masters degree in theology and is a minister of the African Methodist Episcopal Church. Another first cousin, Dr. Ralph Cyril Winge, is an orthodontist, and a martial arts expert who teaches classes in the art of self-defense. First cousin Violette Naomi Winge studied at the California Institute of the Arts and is an actress. She has worked in films and television, but does most of her work on stage. She went to England for one production. Cousin Linda Shavol Strong holds a masters degree in child psychology. My sister Alice Shasta Clark also holds a masters degree in child psychology from Fisk University."

Of all the professionals in the family, one stands out in Claude's mind. "One of Alice's daughters earned a living as a typist, social worker, school teacher, and project director. That same individual is also an ordained minister, writer, and a scholar. She is the recipient of three masters degrees. That person so happens to be my mother, Daima Lockhart Clark."

While Daima was growing up in the 1920s, coming to terms with racial injustice was an ongoing concern. She later wrote down her feelings: "My father, the Reverand C. J. Lockhart, kept us six children alert to the sufferings of our people by discussing with us events that occurred both in our home town and elsewhere. The three oldest children spent the better part of their elementary grades in a segregated school. One parent sued the City of Riverside for refusing his daughter admission into the city pool with her classmates."

"I used to become infuriated whenever he read aloud a story from one of the Negro newspapers or discussed a recent lynching. I became angry with him for revealing the helplessness of our plight with such candor. Then the idea began to occur to me in a very unfocused way, that somehow I had to think my way through this thing. I didn't want to let this awful suffering drive me mad."

"I joined the Civic League, my sister and I being the only youth members. We later joined our high school varsity debate teams and participated in all inter-cultural activities for which we qualified. Gradually my thinking began to focus on questions for which I have since been seeking answers, such as: Why do white people think like they do? Would I think like they think if I were white? Why are there so many differences of opinion among Negroes about what they want for the Negro group and for themselves personally? So it has been, ever since my early awakening to the fact that there is so much suffering in the world around us. I have not been able to quench my desire to add my little bit to the fight for social justice."

As already mentioned, members of Claude's family wrote things down—their feelings, opinions, personal memoirs, and records of births, marriages, and deaths, to be passed on to their children. Claude has pieced together a family history in which the principal characters come alive today. As family archivist and researcher, Claude has traced his mother's line back through six generations to Ralph and Emily Booker in the 1820s. His story is one of countless African-American histories which, like Claude's, begin further back in time. For, beyond the 1820s, Claude only knows for sure that the family roots extend back into the distant past to someone long ago simply known as *The African*.

THE INSPIRATION

Claude Clark would be the first to categorize African-American art as a separate genre from African art.

While acknowledging the aesthetic roots of his own work, in particular his carved wooden stools, Claude is quick to point out that the experiences of African-Americans have shaped their culture in unique ways that find expression in their art. Yet, their African heritage remains a strong factor in creativity, lingering in the folk tales, vernacular architecture, spiritual ceremonies, music, dance, and crafts. As Claude's father declares: "The Black person wants to know his African roots, and art serves him as a source of this identity." Dr. Maulana Karenga, the founder of Kwanzaa in the United States, asserted: "Tradition is our grounding, our cultural anchor, and therefore our starting point" (1988:15). Our self-identity, knowing who we are, then, depends on knowing where we came from, and group identity emerges from a communal heritage, in this case the shared traditions of African culture.

The concept of cultural survivals, or African retentions, in African-American artistic expression has spawned a host of sometimes conflicting scholarly theories. Many stress the similarities rather than the differences between African and African-American art, which too often is viewed as a debased or impure version of African art rather than an entity in its own right — a new expression.

Some art historians claim that the traumatic cultural upheaval of institutional slavery completely eradicated all African traditions in the New World. Judith Wragg Chase writes: "Until the twentieth century, most people accepted the belief that the American Negro had no past worth mentioning; that in many cases his ancestors came from such widely scattered parts of Africa that none of his meager cultural inheritance could have survived" (1971:12). Apparently, African slaves simply lost their culture, and the reappearance of Africanisms or retentions in African-American art today, according to this argument, is attributed to "intuition"— a sort of repressed memory of the collective unconscious, born of cultural amnesia. Thus, the legacy is a spiritual and psychological one.

Jungian-type explanations suggest a broken rather than continuous cultural link, and assimilated African-Americans miraculously rediscovered their dormant heritage generations later. Contrary to this belief, ties with Africa were not broken. New shiploads of slaves arrived all the time from the Guinea Coast; continuous connections to the homeland — cultural infusions from the source — were maintained well into the nineteenth century to jog the memory and keep alive vestiges of African heritage (Chase 1971).

Another academic viewpoint posits that very little, in fact, was lost and many traditions and customs were handed down from one generation to the next. Uninterrupted survival accounts for the

persistence of a few pure African art forms such as the coiled sweetgrass baskets made today by the Gullah (Angola) people of the South Carolina Lowcountry (Vlach 1978). To support this idea, some argue that folkways were able to survive because the social context of daily plantation life was not so radically different for African slaves from that of the homeland. There were parallels between the plantation community and that of the African village; each was a self-contained unit with a rigid hierarchy of work and behavior, and each was a communal organization in which certain people were assigned duties for the entire group. Land was not owned by individuals, but by the community or family (Chase 1971; Fine 1973). Like many African villages, the large plantation was also an agrarian economy, and Africans were used to cultivating crops such as rice and cotton.

In Africa, the artisan was held in high esteem. His position as an integral and important part of the community transferred to the plantation milieu, where the skills of the blacksmith, potter, basketmaker, loom weaver, and woodcarver were in constant demand. Because of the difficulty of importing goods from Europe, Americans depended on locally made utilitarian objects. Plantations were almost entirely self-sufficient, supplying their own subsistence needs. (Chase 1971).

Thus many of the skills of traditional African crafts survived because they were still relevant in new life situations; such knowledge as rope-making, cotton-spinning, and indigo-dyeing were still needed in the Americas. However, the slave artisan produced objects intended for Euro-American consumption and had to conform to European tastes and ideas. "No American slaveholder wanted to have his mantel carved with stylized symbolic designs reflecting African concepts. He was homesick for reminders of his own country" (Chase 1971:56). Instead of fashioning masks and stools, the African woodcarver became a carpenter of European-style furniture, as well as a woodturner, coffin-maker, cooper, house-builder, sign-carver, and wheelwright (Stavisky 1949).

While many traditional craft techniques survived, slaves had few opportunities to apply these skills for artistic self-expression. Some articles were made for personal use by the slaves themselves but these were usually utilitarian in character — rice fanners, rice scoops, hoes, rakes, weaving shuttles — though occasionally an object was embellished with traditional designs (Chase 1971).

While there was an economic neccessity to make domestic items — tools, baskets, clothing, furniture, etc. — for everyone in the community, both slaves and masters alike, ceremonial objects used for tribal rituals had no place in plantation life. In Africa, the kinship of the tribe had been of prime importance; the extended family, ancestor commemoration, and the power and authority of chiefs and kings helped to maintain stable, cohesive social units. "To honor the ancestors is to honor heritage, roots, and our lineage. This focus on lineage is key for it unites the community in a solidarity of past, present, and future generations" (Karenga 1988:21).

In the Americas the social system broke down; families were separated, dispersed, and integrated with families from other tribes. It was impossible to keep up the genealogical chain that traced back to the ancestors; hence, the elaborate rituals associated with ancestor veneration and tribal religion, as well as the handmade objects associated with spiritual life, died a natural death. The folk art that did survive served practical rather than ceremonial purposes. "All during the slaveholding period the most common avenue of creativity open to the black people of America, whether slave or free, was in the handcrafting of necessary articles. This denied them an important emotional and spiritual mode of expression" (Chase 1971:14).

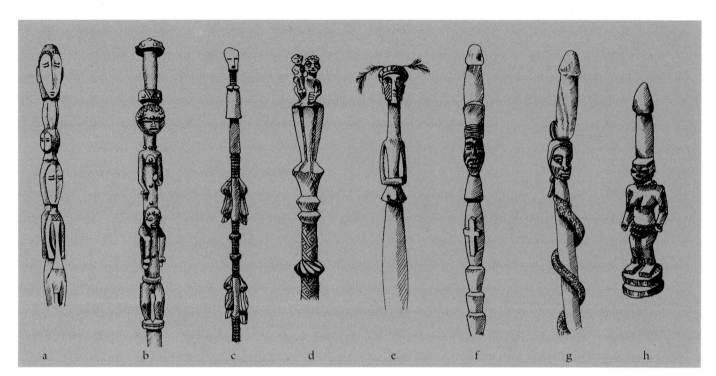

15. African and Haitian staffs.
(Drawings based on photographic sources in the books cited)

a Cult staff used in intiation ceremonies. Lengola people, Central Zaire (Cornet 1975: 124).

b Linguist staff. Baule people, Ivory Coast (Thompson 1974:92, 95).

c Ceremonial staff with pecking bird motifs. Akan/Bono people, Ghana (Cole and Ross 1977:55-56).

d Chief's staff. Kongo people, Zaire (Cornet 1975:36).

e Diviner's fetish staff. Teke people, Zaire (Cornet 1975:46).

f Phallic cane used in Haitian vodou. When a man impersonates a *gede*—a trickster spirit associated with the ancestral dead and with sexuality—he uses the cane as a prop to lewd behavior (Cosentino 1995:397).

g Phallic cane used in Haitian vodou — a sacred belief system originating with the Fon tribe of Dahomey (Benin) where it is called *vodun* (Cosentino 1995:412).

h A counterpart to the Haitian phallic canes can be found in the ceremonial figure symbolizing Legba, the Fon deity of sexual potency, in Dahomey (Cosentino 1995:412).

Moreover, there was a deliberate attempt to stamp out tribal religions. One of the justifications for slavery was the opportunity to "civilize" Africans by imposing European values and beliefs. Slaveholders suppressed African religious practices and customs, particularly those rites surrounding the entrance into adulthood. Overt African expressions had to be camouflaged or practiced secretly.

A further consideration pertaining to African retentions in the New World is that African slaves represented many different tribes and villages in West Africa and were in constant contact with each other on the plantations. Those traditions that flourished, nevertheless, fell prey not only to the influences of the majority culture but to the impact of other Africans as well. Therefore, many village-specific and regional distinctions disappeared into a melting pot of generic West African culture.

Although a few pure African art forms survived intact, the majority adapted to reflect the new life experiences of their makers. African art evolved into hybrid forms — a synthesis of European, American, and African material culture. John Michael Vlach comments: "Afro-American artifacts fall into two major categories: the retained African artifact (comparatively rare) and the hybrid artifact (very common). The retentions carry us back to a time when Africans first arrived on the shores of America. The hybrid objects tell the tale of survival in a creolized culture" (1980:216).

A hybrid art form combines artistic traits in innovative ways; for example, traditional African materials and techniques with European concepts, or vice versa. In the case of African-American quilts, a European textile genre synthesizes with an African aesthetic. The materials, technology and function are Anglo-American, while the design and decoration are African. This is evident in the "spider leg" quilt pattern popular in African-American quilts in the South, derived from the African folk tale hero, Ananse the Spider.

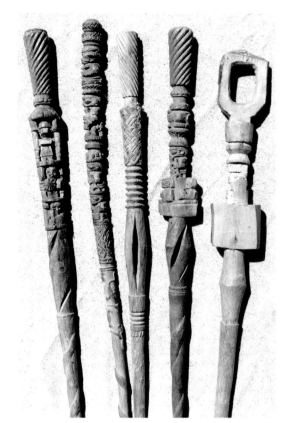

16.
Walking sticks carved from myrtle, cherry, and live oak by Claude Clark, 1980s.

In some cases the artifact stays more or less the same, but the original function changes — the object is used in different ways. A carved diviner's rod or a ceremonial linguist's staff becomes a European-derived carved walking stick (Vlach 1978). The canes carved by Claude Clark have ritual antecedents in West Africa (see illustrations 15 & 16). Sometimes a familiar African form is transferred to another material—a carved wooden cup transforms into a ceramic cup (Chase 1971). True African-American art forms, then, are African adaptations to new social contexts, reinterpretations of African art.

17.
Akan/Ashanti stool resembling a school bus, wood and red enamel paint; Ghana, 20th century (Cole and Ross 1977:213).

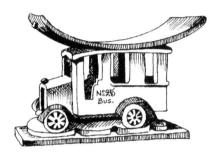

18.
Traditional Akan/Ashanti stools (Hoover 1974:194).

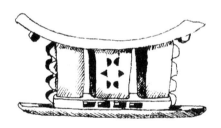

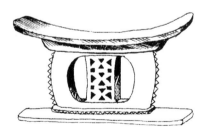

A good example of cultural syncretism and the development of new African-American art styles can be found in the arts of the people known as Maroons in Suriname. Maroons are the descendants of slaves who, starting in the 1670s, escaped from the plantations, regrouped into small bands, and created their own communities in remote rainforest areas. (The word *maroon* is possibly a corruption of the Spanish *cimarron*, meaning fugitive or wild, according to Richard Price [1992], or derives from the French *marron* meaning brown or chestnut-colored.) Maroons came from a variety of tribal and linguistic backgrounds; this cultural diversity combined with Amerindian and European influences to produce uniquely African-American artistic expressions, ideas, and identities.

Another debatable issue is revival rather than survival. Since the civil rights movement of the 1960s and the emergence of black pride, many African-Americans have travelled to Africa to rediscover their roots and reinforce their cultural identity, and African-American artists have sought inspiration for their work. However, those on a pilgrimage to resurrect the past sometimes find disappointment; they feel like "a stranger in a distant land" (Fine 1973:8). The Africa of today, undergoing rapid social and technological change, is not the Africa of three hundred years ago. Colonialism, in Africa as in the United States, influenced indigenous culture, including artistic expression, and missionary dogma imperiled the tribal religions that generated ritual artifacts.

Discussing the destruction of ceremonial objects by Christian and Islamic missionaries, Nelson Graburn writes: "These art objects were often seen as symbols of tribal resistance to colonial or central government authorities and thus were sought out for banning or burning" (1976:299). Furthermore, in the mission schools which dominated education in Colonial Africa, students were taught to look down on their artistic heritage as evidence of the backwardness of their fore-fathers (Bascom 1976).

African art also succumbed to the commercial tourist market for cheap souvenirs, often referred to as "airport art," and to foreign demand from collectors and art galleries. In some cases, once-ceremonial carved stools evolved into miniaturized replicas carved in one hour (Dagan 1988).

An added threat to traditional wood-carving was the depletion of natural resources. Discussing wooden stools from the Okavango Territory in South West Africa (Namibia), Sandelowsky comments: "The style and size of these stools has changed; stools today are rarely as large as the old ones. One reason for this may be a lack of large trees, which have all been cut down to fill the carvers' demands for wood. The indigenous *dolf* tree supplies the raw material for all the carving. Today, these trees are so scarce that the government is planning to plant more and to import wood. Saw mills will be built where the carvers can get precut blocks of wood for their carvings" (1976:362). Moreover, plastic, aluminum cans, and used rubber tires often replace traditional folk art materials nowadays. But then, African folk artists are not so different from folk artists everywhere — resourceful in making use of available materials.

In any discussion of ethnic art, African-American or not, we need to reflect that objects are made by people. Creativity is a thought process, and the cultural aesthetic is a cognitive model — how a group perceives the world in visual terms, manifest in the art. Patterns of thought are translated into patterns in the material expressions of a culture—its artifacts.

While the context of village life was certainly lost in the Americas, and African art accommodated change, what did survive was a culturally-determined approach to creativity, a mental template that governed the rules of composition and stylistic concerns — the internal made external, the intellectual made tangible. For example, the idea of reduction — from complexity to simplicity, and improvisation—the ability to create

19.
Chokwe stools from Okavango Territory
(Sandelowsky 1976:360-1).
a) Traditional style, 19th century

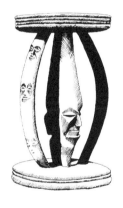

b) Commercial style, 20th century

20.
Saramaka stools from Suriname
(Price and Price 1980:99, 127-9).
a) Curvilinear ribbon style, 20th century.

b) Fancy scroll type with "monkey's tail" spirals, c. 1890-1900.

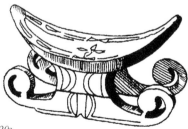

c) Stool collected during the 1920s.

spontaneously without pre-planning, a characteristic found in African-American music and the "break-pattern" logic of pieced quilts (Leon 1987). While improvisation is a universal characteristic of imaginative humans, the extensive sense of improvisation common-place in the Afro-American experience is rather special, according to John Vlach: "In this case spontaneous change represents a cultural norm rather than single, independent inventions. It is an integral part of the process of African art to constantly reshape the old and the familiar into something modern and unique, to simultaneoulsy express one's self and reinforce the image of the community" (1978:3).

Vlach asserts that improvisation is not restricted to one tribe in one area but is "a pan-African reality." Furthermore, he suggests that the inheritance of an improvisational trait provided a coping mechanism during slavery; Africans survived the trauma of cultural disequilibrium because of their ability to modify tradition and adapt. "The adversities which Afro-Americans have endured have encouraged them to be resourceful. They, more than other newcomers to this land, had to reinterpret what for most was common-place" (1978:4).

Summing up the diverse academic opinions on the survival of Africanisms, Vlach states: "It is because of the continued existence of African ideas in America that Afro-American traditions continue to flourish. What is common to objects that are overtly Afro-American and those that manifest only subtle traces of black influence is the retention of a similar creative philosophy. If we are truly to understand Afro-American art and craft, we must understand the intellectual premises upon which their creation is based"(1978:2).

In seeking to explain the visible resem-blance between the arts of the Suriname Maroons and those of West Africa, Sally Price reinforces the belief that it is the continuity of African aesthetic ideas rather than the direct transmission of African artistic forms from

one generation to the next that accounts for survivals. "The early Maroons were not in a position to continue such African traditions as weaving and ivory carving, but they did succeed in carrying on many of the fundamental ideas that underlie the style and meaning of those arts in Africa—ideas about symmetry, color contrast, and syncopation, and above all, the principal understanding that art has a place in all aspects of daily life" (1992:69).

The African legacy, then, is a conceptual one, built of Afrocentric paradigms that enable individuals to reconstruct their world, their aesthetic systems, and their communal ideologies in new contexts. This is the carry-over; we can define "Africanisms" as remnants of thought processes, mental structures, that found their outlet in creative idioms.

While academic studies seek to understand the process of African retentions, in contrast folk artists themselves are often more concerned with just "doing" art than over-analyzing its inspirational source. Describing the goal of Blackstream artists in the 1970s, painter Benny Andrews simply remarked: "I am trying to express or accomplish in my art whatever it is that being Black in this country means, and be very artistic about it" (Fine 1973:247).

Claude Clark's repertoire of woodcarving includes ornately rendered stools, masks, human figures, delicately-executed walking sticks, and totemic animal boxes. The carved stools in particular express a personal identity and are intimately connected to family history, yet they have antecendents in Africa. The link is evident—in the imagery, the symbolism, the carving techniques, and the tools used—but the function has changed from ritual use in tribal society to family use in urban America. Claude's wooden stools are products of an African-American worldview, grounded in the present, though their origins are clearly from another time and place.

That place is West Africa — Benin (Dahomey), Nigeria, Ghana, Cameroon. Though languages and customs differ from

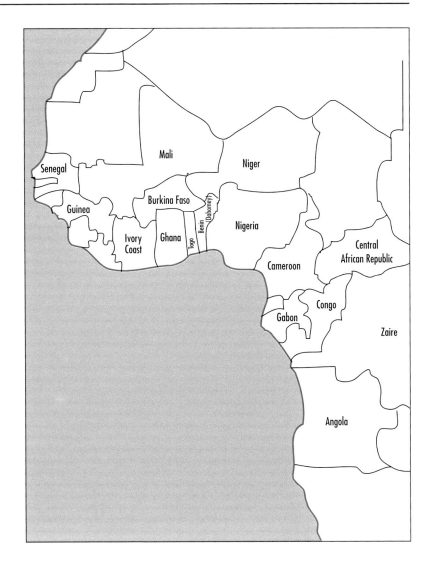

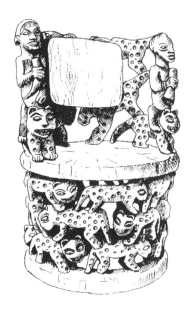

21. *An assortment of stools from Cameroon.*

a) *Throne with leopard imagery, Kom-Tikar area (Thompson 1974:89).*

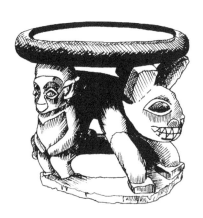

b) *Tikar Tungo stool/table of iroko wood, c.1900 (Gebauer 1979:176, 182).*

c) *Babanki stool with leopard figure, Grasslands region (Thompson 1974:87).*

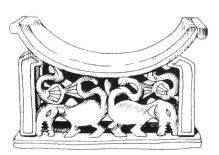

d) *Duala stool of obeche wood with mythological fish and sea animals motifs, 1899. Coastal rainforests (Gebauer 1979:312-3).*

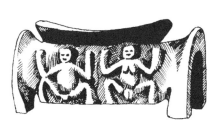

e) *Mambila birthing stool (Thompson 1974:91).*

country to country, and from village to village, some cultural traits overlap, and many societies within the region share common beliefs and traditions associated with stools. Generally, a stool has cultural significance beyond its domestic and utilitarian function as a seat, and there are rules and taboos concerning its usage. Symbolic motifs in the carved decorations determine its ritual or domestic category and who is entitled to own it (Warren and Andrews 1977). Certain types denote social rank, others are designated for children only or for adults. Stools are also gender specific — there are male stools and female stools. Thus a stool is a personal rather than a communal possession and there is a close relationship between a stool and its owner (Biebuyck 1977; Gebauer 1979).

The Ashanti people, a confederation of Akan states in central Ghana, believe that a person's spirit resides in his/her stool, even after death, and that there can be no secrets between a man and his stool (Kyerematen 1964). Hence, when vacating a stool, the owner must tilt it on its side to prevent someone else's spirit from occupying it.

Stools figure prominently in rites of passage and other transitional stages of life. The Mambila people in Cameroon have a special birthing stool (see illustration # 21e) used when a woman experiences a difficult delivery; she is seated upon the stool and told to "confess." Supposedly the release of tension on admitting her repressed guilt and anxiety eases her labor (Thompson 1974). In Ashanti society, a stool is a father's first gift to his child when he/she starts to crawl; crawling signifies that the child will probably survive past infancy. On reaching puberty, a young girl is placed on a special stool during nubility rites, and youths on reaching manhood are circumcized sitting on an intiation stool (Cole and Ross 1977). Small wooden replicas of initiation stools serve as emblems for those given the authority to perform circumcision rites. Customarily a groom presents his new wife with a "lover's back stool" as a token of his affection and to ensure

her fidelity. And it is on a stool that the corpse is bathed before being laid in state. In Mali, Dogon men keep their personal stools in the men's house for ritual use; on the death of its owner, a stool is removed for the burial ceremony then taken to the house of the deceased for its final resting place. Among the Nyanga of Eastern Zaire, a woman culminates her mourning rites for a departed husband or son by having her hair shaved on the *utebe* stool, usually reserved for men (Biebuyck 1977).

In Ashanti society a stool denotes the social status of its owner and, as such, is the principal symbol of a chief's political power and authority, along with highly-prized animal skins such as leopard pelts. The stool is synonymous with the chief's high office and when a ruler dies they say "the stool has fallen" (Sarpong 1971:8). In Ghana an incumbent ruler undergoes an "enstoolment" before taking office (similar to the enthrone-ment of British royalty during a coronation). The new king is placed on a ceremonial stool three times as part of the inauguration. Ceremonial stools are distinguished by their shape and symbolic designs, such as the "knot of wisdom" motif (*nyansapol*) which signifies the chief's promise to his people, on his accession, to bind the nation together through prudent administration (Ross and Cole 1977; Kyerematen 1964).

In Ghana today, local people still identify strongly with their traditional leaders. "Many chiefs enstooled in recent years are university graduates with progressive ideas of communi-ty self-help. Continuity with earlier traditions and values thus constantly interacts with change and innovation"(Cole and Ross 1977:3).

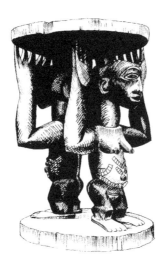

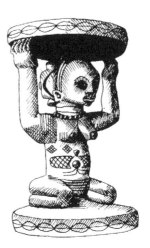

22. *West African stools with human figures.*
a) *Hemba stool, Eastern Zaire*
 (Cornet 1975:122).

b) *Luba royal stool, Kabalo region of Zaire,*
 late 19th century.
 (Sotherbys 1991:#88).

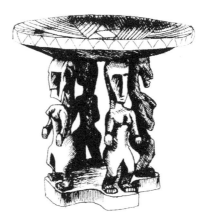

c) *Bambara stool, Mali*
 (Hoover 1974:#14).

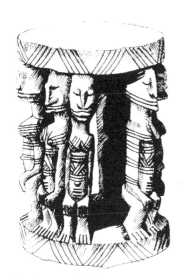

d) *Dogon stool, Mali*
 (Hoover 1974:#68).

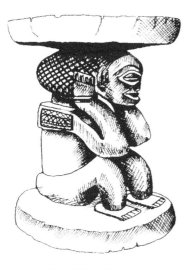

e) *Chokwe chief's stool, Angola*
 (Thompson 1974:100)

There are many rites in connection with woodcarving in Africa because wood is used for a variety of cult objects, the creation of which is an extremely sacred act. Thus, a chief's stool begins life with a prayer and libation to appease the spirit of the tree before felling and to bless the carver's tools. Additionally, before beginning work the woodcarver undergoes some kind of ritual cleansing, refraining from all pleasure, and then devotes himself to his work in seclusion (Chase 1971).

Deprived of its natural home, the soul of the tree will henceforth reside in the stool, and rites must also be performed upon completion of the stool, with an animal sacrifice. The wood of choice in Ghana is called sese (*Funtumia africana* Stapf, from the Family *Aporynaceae*); it's common name is "false rubber tree" because it produces a sticky latex resin. It is a soft, white wood that is durable, light and portable and grows throughout West Africa (Kyerematen 1964).

The Ashanti revere a divine stool, called Asika-Dwa Kofi, "the golden stool that was born on a Friday" (Ross and Cole 1977:137). They believe it embodies the soul and destiny of the Ashanti nation and, as such, it is a symbol of the people rather than their ruler. Regarded as a living being and treated with awe, the stool has its own throne, named Hwedomtea, its own set of regalia, its own bodyguard, and attendants to feed it and clothe it with ornaments. No one sits on the golden stool; it would be an affrontery to place one's backside on the destiny of the people. During Ghana's colonial period, Asika-Dwa Kofi was the major cause of the last armed conflict between the Ashanti and the British in 1900 when the governor, Sir Frederick Hodgson, demanded to sit on the Golden Stool, thereby precipitating bloody retaliation and a bitter war (Kyerematen 1964).

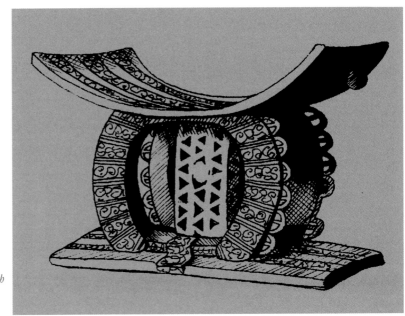

23.
Ashanti chief's stool, wood with
silver repoussé, 1873
(Cole and Ross 1977:138).

A chief's personal stool is more than royal insignia; it houses his spirit, in this world and the next, and must be preserved after the death of its owner. Thus, through the medium of the stool, a deceased ruler can keep in touch with his subjects and continue to provide counsel and protect the community in the afterlife as he did on Earth. A chief's stool therefore functions as a shrine for the soul, a memorial to the ancestor, and a vehicle of communication.

Not all West African tribes share the Ashanti belief that stools house the spirits of the dead. Among the Bamun of Cameroon: "These royal objects received 'life force' from their owners. They died when their owners died. At the death of the stool's royal master, it could go with him into the grave or be exposed to the tropical elements to hasten its decay" (Gebauer 1979:89).

To preserve an Ashanti chief's stool, the wood is ceremonially blackened, first by smoking and then by smearing with a mixture of kitchen soot and egg yolk. The greatest honor bestowed on an Ashanti chief is to have his stool blackened after his death, for only exemplary rulers are privileged in this manner (Kyerematen 1964). To the living, it becomes a visible and permanent reminder of a beloved ruler.

Blackened stools are guarded in a special stool-house, *nkonnwafiesso*, where they are placed on animal skins or wooden platforms, never directly on the ground, and shown due respect. Blackened stools become pivotal objects in rites associated with ancestor worship and are offered food and libations on appointed days. They are brought out publicly for festivals that pay homage to the ancestors, such as the Adae festivals — days set aside for remembrance of late rulers and an occasion to beseech favors, blessings, good health and prosperity for the village. The stools are offered mashed yams or plantain, and the blood and fat from a sacrificed sheep are smeared over each stool. The cooked meat is also offered to the stools, after which they are returned to their royal mausoleum in a solemn procession (Sarpong 1971).

Ancestor stools feature in the Afahye festival, held annually in October to celebrate the "first fruits of the harvest" or the first crop of yams—an important food staple in West Africa. Blackened stools are carried to the river and sprinkled with water; after the ritual ablutions they return to their temple abode where a portion of the new crop is cooked and placed on each stool. Other occasions involving the blackened stools include the child-naming ceremony of a royal baby, the puberty rites of a girl of royal blood, and the wedding of a member of the royal clan, when a libation is poured on the stools as a fertility rite for the new couple (Sarpong 1971).

Africans transplanted to the New World maintained or adapted only those customs and traditions that were relevant to their daily and spiritual needs in the new society. Tribal life disappeared, and with it the social hierarchy of chieftainship and the regalia associated with the office. Ceremonial stools became obsolete.

Contemporary artist Claude Lockhart Clark also carves stools, but they are products of a different age and society. The context and function have changed; they are no longer ceremonial, no longer memorials to deceased tribal chiefs, nor venerated as divine personifications of a nation. However, Claude's stools relate to African prototypes in their association with ancestors. His stools, like those of his African forebears, are carved as memorials to family members, though lacking a ritual purpose.

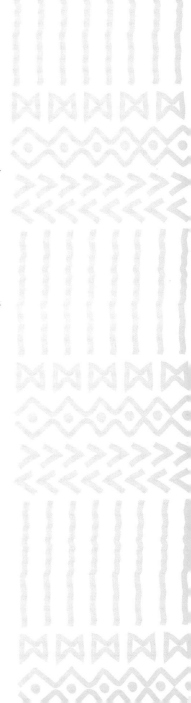

THE WORK

While the African aesthetic legacy is apparent in his work, Claude defines it in terms of the African-American experience that spans two continents.

"It is important that we be the architects and builders of our own culture. We cannot afford to use our relocation in America with our subsequent loss of cultural tradition and need for moderization as an excuse for failure to address ourselves to this dilemma. As African-Americans, our experiences have been different from those in the homeland. We must assert ourselves to learn our African heritage and African crafts, then apply these tools to our experiences here in America."

Claude comments: "People usually ask if I am copying sculpture from Africa. They want to know which African tradition I use stylistically and what do my sculptures represent in that society, in Africa. They never ask what do I do that is different, and what does my work represent in the United States. They always think it represents something somewhere else rather than here. This is a new beginning."

Claude maintains that using African motifs does not make a work of art "African." He describes motifs as "veneer" or "salad dressing" and claims that some artists use African motifs over a European art foundation. "Motifs are shallow, surface coverings. They are not the materials that contain the substance of an art. They can prove very valuable in a work, but they depend on a structure or foundation for support. It is the foundation that identifies the art, not its motif. Sure, African motifs are used in African art, but the art doesn't become "African" because of the motif. It is African because the art foundation on which it rests is African."

"I mix a few African designs with my new designs. All of it is African in principle, but most people looking at my work think that it is pure African tradition. The style is different, but someone with only a general knowledge of African art might not notice at first. I do not copy other artists' work when I carve wood. The tools I use, the stools and walking sticks, are about the only things of African origin, and everything else is new. I developed my own shapes for each item I make, and new symbols, and the patterns and designs are mine as well, like my butterfly foot-rests. My forms are not to be found repeated anywhere in African art. It will take a while, possibly even years, to build up enough new stuff before the public realizes that Claude Clark has a whole new thing going here."

"It is very difficult to come up with new principles in art. Most of us develop a new style of work, but it is even harder yet to come up with a new system of art. I've come up with new shapes and patterns which fall along old principle guidelines. Thus I've developed my own style of art but a new system of art I will leave for another lifetime."

Claude's handcarved stools are a good example of his thinking. At first glance they look like West African stools, but the images and symbolism have personal significance and are closely bound to Claude's family history. Claude explains: "The stools are an extension of cultures which are very ancient. They are objects that I've adapted to a different time and place, and represent a living heritage." Two of the stools are in fact memorials to the earliest known African-Americans in his family, Ralph Booker and his wife Emily Booth, both born in the 1820s.

While making stools to house the spirits of dead ancestors is common practice in many West African societies, Claude's stools house human relics rather than human souls. Claude designed stools to contain "ancestor urns"— repositories for braided locks of hair from deceased female relatives, which is not a documented tradition in Africa. Claude knows of only one instance of human hair being

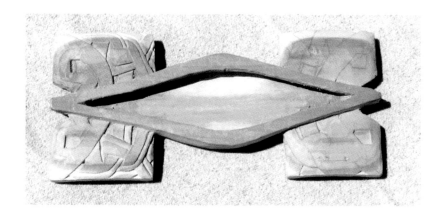

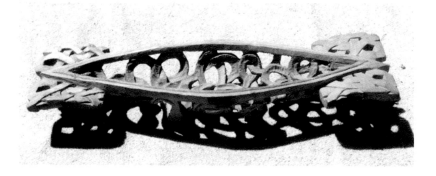

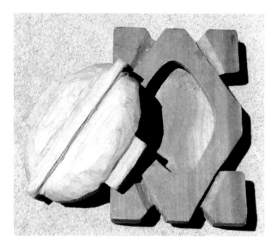

24.
*Fish-shaped tray of cherry
wood, in progress, 1996.*
25.
*Fish tray carved from
willow, 1980s.*
26.
*Turtle box of cherry,
in progress, 1996.*

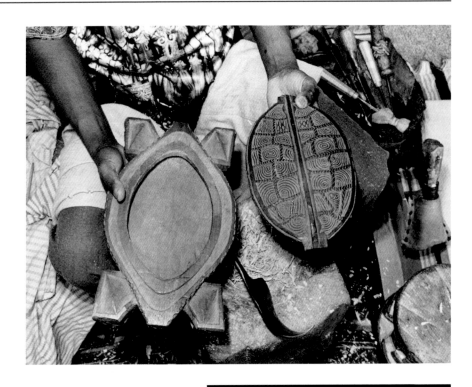

27.

Finished turtle box, carved from cherry in 1985; part of a series inspired by West African folk tales.

28.

Wooden mask, "Macho." Carved from ash in 1979.

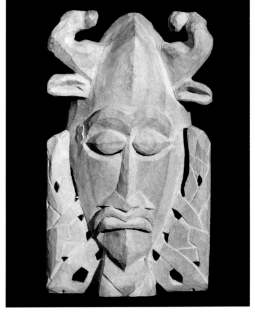

placed in a stool: "Around 1697 when Chief Priest Okomfo Anokye and his cousin Nana Osei Tutu united the Ashanti Nation, symbolized by the Golden Stool *(Asikadwa Kofi)*, they took the clipped finger nails and hair from the heads of state representing the various ethnic groups within the newly-founded Ashanti Confederation, made a potion from the clippings and hair, and placed it inside the Golden Stool. This is the only African stool that I know of that contains human hair, and I know of none which carry braided locks of hair."

In Claude's family, the custom of "passing on the locks" to memorialize the dead was a matrilinear practice. Women cut and saved locks of their hair, meticulously labelled with their maiden names and the date when each lock was cut, to bequeath to their daughters as a token of remembrance. Hair was never removed after a person died. The custom eventually died out with the third generation of African-Americans in the family. However, those locks already in existence continue to be handed down from mother to daughter. Claude adds: "These stools have nothing to do with my father's people or the patrilineal ancestors. Those branches of the family know nothing about it."

Claude is not aware of other African-American families that share this tradition. "Africans in America don't save human hair, to my knowledge, or pass on locks of hair, unless of West Indian background. Some mulattoes in Haiti save the hair of women ancestors, weave necklaces out of them, and keep them in jewelry boxes. African-Americans traditionally burned hair to prevent anyone from practising bad *juju* with it. The Booth/Booker descent groups of my family were different. The matrilineal descent group never believed in bad *juju* and they practised cutting and saving hair locks. The locks in our household used to be kept in a gold-plated locket case that looked like an old watch case."

One of the last women to cut locks was Claude's grandaunt, Abilene Arubella Buchanan, a hairdresser by profession. Like her school teacher relatives, she kept very accurate written records, carefully labelling each lock of hair. These passed to Claude's sister in 1964 and later shifted to Claude for safekeeping. Whereas the male line of the family cannot inherit locks of hair, Claude sees himself as guardian rather than owner of these family heirlooms: "I belong to the wrong gender for any ownership of these items. Preserved in the cavities of the stools, the locks are held in safe-keeping for my sister, Alice Shasta Pippins, and her female descendants who are the designated owners of the locks."

In 1974 Claude began carving two stools, each fashioned from a single block of wood with four figures as support columns between the base and the seat. Inside the structure of each stool he incorporated a free-moving, hollow, wooden head to contain the locks. Claude named the stools "Ralph" and "Emma" after his great-great-grandparents Ralph and Emily Booker. Claude does not consider them true ancestor stools, like the blackened stools of Ashanti chiefs, because they were not owned or used by Ralph and Emma or passed on to their children. Claude terms them "domestic stools" — part stool and part urn — or "adult stools." Yet, the stools resemble African ceremonial stools in their association with rites of passage — remembrance of the dead. To Claude they represent "the beginning of a new culture."

Concerning African counterparts to Claude's stools, he emphasizes that it is the idea behind the work that differenciates the two—an old set of principles utilized in a fresh way for a different purpose. While there may be similarities in appearance, his domestic stools represent new ideas. "I have not yet seen an African stool with a head inside. That doesn't mean there aren't African stools with wooden heads inside. The question is, why would they be made? What event or purpose

would require an African artist today to make such a stool? Is it because the stool makes great sales in the market-place, or is there a religious reason to place a wooden head inside?"

The nearest African comparison to Claude's urns are the wooden skull shrines made by the Chokwe people in the border regions of Angola, Zambia, and Zaire. Called *korwar*, the vessels are carved human figures that contain the preserved skulls of ancestors. Warner Muensterberger writes: "We do not know of the existence of skull shrines of this type anywhere else" (1971:7).

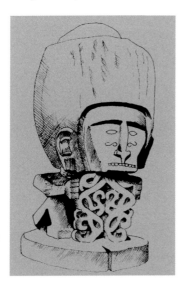

29.
Korwar figure of the Chokwe people, no date. In the collections of the Rijksmuseum voor Volkenkunde, Leiden (Muensterberger 1971:6).

Using California myrtle wood, Claude carved the male domestic stool in 1979. Initially he called the stool *Ijo'ko-Ajo*, which he took from a Yoruba expression meaning "council seat." Claude explains: "In Africa a council consisted of elder male members of a family or community, a dozen or more seated around a circle facing each other. In my sculptured stool, the council is represented by four figures and one head. The head inside the stool, which contains the locks, can be likened to the skull of Asarus that was kept in an earthenware jar after his death by council members belonging to the cult of Asaru, or Osiris, in ancient Egypt. The four standing figures on the outer rim of the stool have entrapped the head so that it won't come out. The head was actually carved while inside the stool. It was never taken out." The head contains two locks of hair, one from Sophie Booker in 1910, the other from Bella Booker in 1935.

Claude later renamed the stool Ralph after his great-great-grandfather. He discovered that *Ralph* is from the Old English word *Raedwulf*, derived from *raed* meaning counsel and *wulf* meaning wolf. The name later became Radulf, then Rafe and Ralf during the 16th century. By the 18th century the "ph" replaced the "f," falsely suggesting a Greek origin. Therefore Ralph literally means "wolf counsel." He notes: "I have used both counsel and council in describing the Ralph stool. Counsel represents the act of giving advice or information, and the other council is a decision-making body or group. The whole idea behind the name and the stool is that the person owning or using this stool will eventually provide both counsel and council."

The female domestic stool, first called *Ijo'ko-wole*, (meaning "take a seat" in Yoruba) was also changed, to Emma, after his great-great-grandmother. Claude found that the name Emma derives from two Old German words — *ermin*, meaning whole, and *irmin* meaning universal — and was introduced into England in the tenth century by Emma, daughter of Richard I, Duke of Normandy.

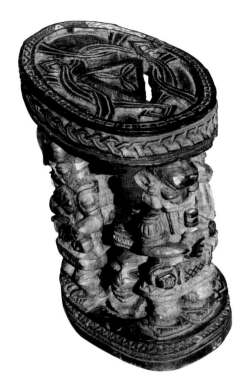

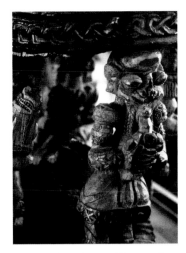

30 a. Ralph stool, carved from myrtle wood, 1979.
30 b. Detail of Ralph stool.

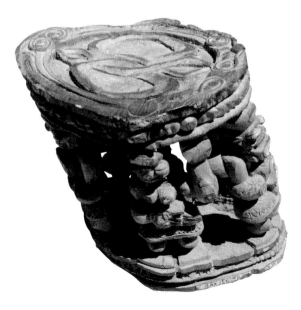

31
Emma stool, carved from myrtle wood, 1979.

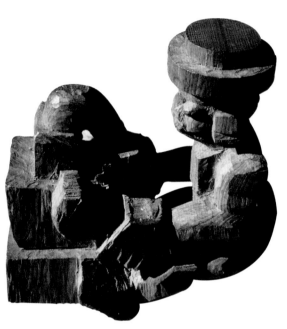

32.

Claude with his personal stool, named Kwaku. Oakland, 1996.

33.

Small sculpture of a wood-carver at work, 1980s.

A third stool, carved from California live oak in 1975, reflects Claude's self-identity and, like the personal stools of the Ashanti, there is a close relationship between the stool and its owner. Claude calls it a work stool or "trades stool," because "it belongs to me, a tradesman. I am an artist and the stool is a symbol of my profession. I am a woodcarver, family chronologist, and a storyteller, and the stool was carved to resemble my day of birth symbol which is a spider." The spider images are carved between the seat and the base, their round bodies and outstretched legs forming the surface design around the circumference of the stool. The seat has a backrest, permitting the wood carver to spend long hours at his work.

This stool is not unlike a Bamun spider stool of the Cameroon grasslands (Dagan 1985, illustration # 54). Throughout West Africa the spider is a popular folklore figure and a common visual motif. There are two types of spider symbols — the web-weaving spider (called Anansi among the Ashanti)

and the tarantula or earth spider, also called the trap-door spider. Anansi is associated with solar and celestial myths and with the invention of spinning and weaving. It is generally considered a harbinger of good luck in many Ashanti legends. Among the Tikar people of Cameroon, the spider is a welcome guest in any home as a symbol of peace and protection (Gebauer 1979). The earth spider has a more sinister character. The Basa, and other tribes in Cameroon, use it for divination practices (Balandier and Maquet 1974).

Claude believes that the Ashanti adage *There are no secrets kept between a man and his stool* derives from the association of stools with thought process. "In West Africa, the weaver, blacksmith and woodcarver work while seated, and a person is believed to be thinking when he is sitting; it is considered sacrilegious to tamper with a craftsman's working place or bother him while he is thinking. Iron tools, wooden stools, masks, figures, textiles, are all products of man's rational thinking and communion with the spirits."

Claude named his personal stool Kwaku which signifies his date of birth. "I was born on March 28, 1945, which happened to fall on a Wednesday, the fourth day of the week, which corresponds with the fifth day in Ghana. It is called Wukuda, day of fame. A boy child born on that day would be called Kwaku. Ananse is an Akan word for spider, and Ananse is the culture hero of West Africa. In Akan folkore, Kwaku Ananse, the spider born on the fifth day, is an artist. He spins artwork from webs. Kwaku Ananase spun stories too, about the web of life. Animals were used in place of human characters, and people were captivated by the lessons and morals obtained from the fables. Did you ever hear of Uncle Remus stories? Brother Rabbit is really Kwaku. We were taught in this country that snakes and spiders were something to fear, so we use a rabbit in place of a spider."

Claude continues: "The origins of Aesop's fables are African, though usually attributed to Greece. Aesop was an African storyteller

34.
Web-weaving spider motif incised on an ivory tusk used as a royal footrest at state functions. Tikar/Tungo, Cameroon, 19th century (Gebauer 1979:201, 375).

who only spent six months in Greece, but those six months made his stories world-renowned. How can something be 'Greek' when it has only been in Greece for six months? And, over half the stories did not originate with Aesop; he was telling African folk tales, Kwaku's stories, which are still to be found in Africa. The original versions of the fables were very long but most of them could be condensed to a single paragraph, then converted to a single proverb, and from that to a single word or idea. This is a fundamental characteristic of African artistic expression — reduction."

As an example, Claude cites the story of *The Crow and the Pitcher*: Once a thirsty crow found water in a pitcher but couldn't drink the water because the neck of the vessel was too long for the short length of her bill. It seemed as though she would die of thirst within sight of a remedy. She formed a plan. She dropped pebbles into the pitcher until the water level rose high enough for her to drink.

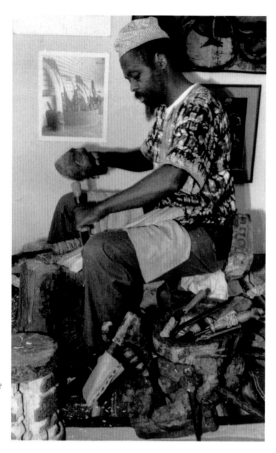

The work stool, Kwaku, has a companion piece of sculpture which functions as a tool holder. It is called Arugba, calabash carrier, and is a carving of a woman balancing a calabash bowl on her head with both arms raised to support the vessel. The spaces between the arms and legs, and the cavity inside the vessel, are compartments for sorting the tools so that the woodcarver can easily find the tool he needs while working.

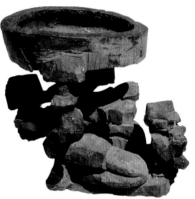

35.

When carving a piece of wood, Claude's tools are near at hand in the Arugba container. California Academy of Sciences, 1991.

36.
Arugba is carved from myrtle wood.

The story illustrates Claude's conviction: "If we wanted to sum up this fable in one sentence, we could simply say: Necessity is the mother of invention. And if we wanted an idea or a word which would sum up the moral to be learned, we could choose *ingenuity*. African sculpture is composed in much the same way. We have a narrative, or story to tell, when we start composing our work. However, we can never use the story as it is. We must condense our narrative to one word, one image, one idea."

In Claude's mind, "Kwaku represents survival of a culture as well as the source of the carving tools, the source of the images, and the narrative source of our living family heritage. But the stools and the archives also represent the beginnings of a new culture, and new family awareness for African-Americans as well."

Arugba depicts a kneeling woman symbolically offering food to the Yoruba orisha Ogun, deity of iron. She portrays a devotee giving thanks for the use of Ogun's tools and also connotes the woodcarver's acknowledgment that, only with Ogun's blessings, can he perform his tasks safely and successfully.

Claude uses a variety of adzes, chisels, mattocks, knives and mallets. When he first started to carve wood, he looked at African sculpture and asked himself: What kind of tool would they use to get that result? He then sent drawings of tools he imagined to friends in West Africa, and, sure enough, handforged steel blades that matched his drawings began arriving. He now imports the steel blades from West Africa and carves the wooden handles — miniature works of art in themselves.

The traditional adze, an oblong tool with a wooden handle and a flat, sharp metal end, is used to block out major sections of the form, such as the head, arms, and legs.

Chisels are used to punch holes and remove wood from hard-to-reach areas. Carving knives smooth out the forms and etch lines for facial expressions and surface designs.

Claude prefers medium to hard woods such as live oak, myrtle, cherry, and poplar. He gets his wood from many sources; sometimes he looks for old tree stumps, telephone poles or firewood. He often gets donations from park rangers or city tree cutters who fell old or leaning trees that are hazardous to public safety.

Watching Claude work, woodcarving becomes stage performance. He carves with lightning speed, using left or right hand with equal dexterity. Within a couple of hours he quickly transforms a block of wood into a work of art.

In summary, the work of Claude Clark illustrates the concept of tradition as both continuity and change. Stylistically the carved stools have evolved from a West African aesthetic. His tools are of African design and he uses African-derived woodcarving techniques. The stools are also imbued with personal signifcance, denoting family customs and lineage that define his ethnic identity. They represent continuity in the New World.

However, Claude's stools are not mechanical reproductions of African protoypes. The artist has absorbed fresh ideas into his repertoire to produce work that communicates different messages. The function of the stools has changed to take on new meanings for one African-American family. Though they relate to African antecedents in their association with ancestors, the stools are no longer eremonial products of an African village; they serve a different purpose in the context of contemporary urban life and manifest African-American family values. Claude's stools house the locks of hair of female relatives rather than the souls of tribal chiefs.

Thus, in Claude's work we can see that continuity and change go hand in hand. Cultural heritage is a connecting thread with the past, an unbroken link through time.

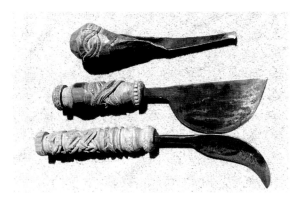

37.
Claude's tools with handcarved handles from California live oak.
a) Adzes.
b) Knives and chisel.
c) Axes with handles inspired by Luba hairstyles.

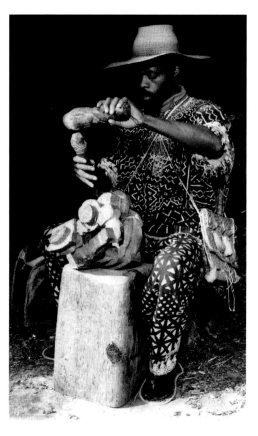

38.
Claude carving with
mallet and chisel.
Oakland, 1979.

Folkways and customs, handed down from one generation to the next in the context of community life, help sustain a group's ethnic identity; knowing who we are depends on knowing where we came from. Shared traditions bind people together and give a feeling of belonging.

Though tradition by definition is continuity, to remain relevant as living, dynamic forms of expression through time, folk art genres must adapt to new social situations to reflect the new life experiences of their makers. As people's ideas change, so do their artifacts. Therefore cultural traditions must accommodate change to reflect their own time and place.

Conceptually, then, tradition is a reinterpretation of the past rather than a clone; it represents old ideas rethought and reinvented in new contexts. Though the traditional artist works within culturally-prescribed boundaries, the individual can improvise, experiment, and expand the traditional repertoire in new directions that satisfy personal creativity as well as group aesthetic.

The traditional artist is also custodian and conservationist — the guardian of a cultural legacy. Cultural conservation is at the heart of issues concerning ethnic identity. While some claim that the United States is a cultural melting pot, it is in fact a mosaic of ethnically distinct groups striving to co-exist side by side while maintaining their differences within a pluralistic society. Ethnic groups need their cultural traditions to reinforce and nourish self-image.

Ethnic groups also seek recognition and acceptance of their differences within the broader framework of society. Folk arts such as music, dance, and crafts, embody a group's beliefs and values and, as such, are an excellent medium through which to communicate ideas about ethnicity in positive ways to outsiders, especially where misconceptions and negative stereotypes exist. Thus, cultural conservation is vital not only for the psychological well-being of a minority group but also for the psychological well-being of a multi-ethnic society.

The San Francisco Bay Area thrives on its cultural diversity. Among the many immigrant and Native American groups maintaining their ethnic heritage, it is the tradition-bearers like Claude Clark who contribute to the variety of artistic expressions that make modern urban life stimulating and who ensure that this legacy of cultural pluralism will pass to future generations.

BIBLIOGRAPHY

Andrews, J. Kweku and D. M. Warren. *An Ethnoscientific Approach to Akan Arts and Aesthetics.* Philadelphia: Institute for the Study of Human Issues, 1977.

Balandier, Georges and Jacques Maquet. *Dictionary of Black African Civilization.* New York: Leon Amiel Publishers, 1974.

Bascom, William. "Changing African Art." In *Ethnic and Tourist Arts,* Nelson Graburn, Ed.. Berkeley: University of California Press, 1976.

Biebuyck, Daniel P. *Symbolism of the Lega Stool.* Philadelphia: Institute for the Study of Human Issues, 1977.

Chase, Judith Wragg. *Afro-American Art and Craft.* New York: Van Nostrand Reinhold, 1971.

Cole, Herbert M. and Doran M. Ross. *The Arts of Ghana.* Los Angeles: Museum of Cultural History, UCLA, 1977.

Collins, Willie R. *African-American Traditional Arts and Folklife in Oakland and the East Bay.* Oakland: City of Oakland Cultural Arts Division, 1992.

Cornet, Joseph. *Art from Zaire.* Exhibit catalog, Institute of the National Museums of Zaire, 1975.

Cosentino, Donald J., Ed. *Sacred Arts of Haitian Vodou.* Los Angeles: UCLA Fowler Museum, 1995.

Crouchett, Lawrence P., Lonnie Bunch, and Martha Kendall Winnacker. *Visions Toward Tomorrow: The History of the East Bay Afro-American Community, 1852 - 1977.* Oakland: Center for Afro-American History and Life, 1989.

Dagan, Esther A. *Man at Rest.* Montreal: The Saidye Bronfman Center, 1985.

—- *Asante Stools.* Montreal: Galerie Amrad African Arts, 1988.

Daniels, Douglas H. *Pioneer Urbanites: A Social and Cultural History of Black San Francisco.* Philadelphia: Temple University Press, 1980.

Evans, David. "Afro-American Folk Sculpture from Parchmau Penitentiary." *Mississippi Folklore Register,* vol. 6, 141-152, 1972.

Ferris, William. "Visions in Afro-American Folk Art: The Scupture of James Thomas." *Journal of American Folklore,* LXXXVIII (1975), 115-131.

—- *Afro-American Folk Arts and Crafts.* Jackson: University of Mississippi, 1983.

Fine, Elsa Honig. *The Afro-American Artist.* New York: Holt, Rinehart and Winston, 1973.

Gebauer, Paul. *Art of Cameroon.* Portland: The Portland Art Museum, 1979.

Goode, Kenneth G. *California's Black Pioneers: A Brief Historical Survey.* Santa Barbara: McNally and Lofton, 1984.

Graburn, Nelson H. H., Ed. *Ethnic and Tourist Arts: Cultural Expressions from the Fourth World.* Berkeley: University of California Press, 1976.

Hemphill, Herbert W. *Folk Sculpture USA.* New York: The Brooklyn Museum, 1976.

Hoover, F. Louis, Ed. *African Art*. Normal-Bloomington: Illinois State University, 1974.

Karenga, Maulana. *The African-American Holiday of Kwanzaa*. Los Angeles: University of Sankore Press, 1988.

Kyerematen, A. A. Y. *Panoply of Ghana*. New York: Frederick A. Praeger, 1964.

Lapp, Rudolph M. *Blacks in Gold Rush California*. New Haven: Yale University Press, 1977.

—- *Afro-Americans in California*. San Francisco: Boyd and Fraser, 1987.

Lemke-Santangelo, Gretchen. *Abiding Courage*. Chapel Hill: University of North Carolina Press, 1996.

Leon, Eli. *Who'd a Thought It: Improvisation in African-American Quiltmaking*. San Francisco: The San Francisco Craft and Folk Art Museum, 1987.

Lewis, Samella. *Art: African American*. New York: Harcourt Brace Jovanovich, Inc., 1978.

Muensterberger, Warner. "Some Elements of Artistic Creativity Among Primitive Peoples." In *Art and Aesthetics in Primitive Societies*, Carol F. Jopling, Ed., New York: E. P. Dutton, 1971.

Murphy, Joseph M. *Santeria, An African Religion in America*. Boston: Beacon Press, 1988.

Osumare, Halifu. "Sacred Dance/Drumming: African Belief Systems in Oakland." In *African-American Traditional Arts and Folklife in Oakland and the East Bay*, Willie Collins, Ed.. Oakland: City of Oakland Cultural Arts Division, 1992.

Porter, James A. *Modern Negro Art*. New York: Dryden Press, 1943.

Price, Richard. "Maroons: Rebel Slaves in the Americas." In *1992 Festival of American Folklife*. Washington, DC: Smithsonian Institution, 1992.

—- and Sally Price. *Afro-American Arts of the Suriname Rain Forest*. Los Angeles: Museum of Cultural History, UCLA, 1980.

Price, Sally. "Arts of the Suriname Maroons." In *1992 Festival of American Folklife*. Washington, DC: Smithsonian Institution, 1992.

Sandelowsky, B. H. "Functional and Tourist Art Along the Okavango River." In *Tourist and Ethnic Art*, Nelson Graburn, Ed.. Berkeley: University of California Press, 1976.

Sarpong, Peter. *The Sacred Stools of the Akan*. Accra-Tema: Ghana Publishing Company, 1971

Shapiro, Linn, Ed. *Black People and their Culture: Selected Writings from the African Diaspora*. Washington, D.C.: Smithsonian Institution, 1976.

Sotheby's auction catalog. *The Kuhn Collection of African Art*. New York, 11/20/91.

Stavisky, Leonard Price. "Negro Craftsmanship in Early America." *American Historical Review*, vol. 54, 1949.

Thompson, Robert Farris. *African Art in Motion*. Los Angeles: University of California Press, 1974.

Thurman, Sue Bailey. *Pioneers of Negro Origin in California*. San Francisco: Acme Publishing, 1949.

Vlach, John Michael. *The Afro-American Tradition in Decorative Arts.* Cleveland: The Cleveland Museum of Art, 1978.

—- "Arrival and Survival: The Maintenance of an Afro-American Tradition in Folk Art and Craft." In *Perspectives on American Folk Art*, Ian M. G. Quimby and Scott T. Swank, Eds., 177-217. New York: W. W. Norton, 1980.

Wahlman, Maude. *Contemporary African Arts.* Chicago: Field Museum of Natural History, 1974.

Wollenburg, Charles. *Ethnic Conflict in California History.* Los Angeles: Tinnon Brown, Inc., 1969.